the botanical hand-lettering workbook

workbook

the botani hand-let. workbook

the botanical hand-letterin workbook

the botanical hand-lettering workbook

the botanical hand-lettering workbook

the botanical hand-lettering workbook

the botanical hand-letterin workbook

the

this workbook
belongs to:

_ _ _ _ _ _ _ _ _ _ _ _ _ _ _ _ _

the botanical HAND-LETTERING workbook

Draw Whimsical & Decorative Styles & Scripts

BY BETHANY ROBERTSON

Ulysses Press

Published in the U.S. by
ULYSSES PRESS
P.O. Box 3440
Berkeley, CA 94703
www.ulyssespress.com

ISBN: 978-1-61243-484-1
Library of Congress Control Number: 2015937553

Printed in Canada by Marquis Book Printing

10 9 8 7 6 5 4

Acquisitions Editor: Keith Riegert
Managing Editor: Claire Chun
Project Editor: Alice Riegert
Copyeditor: Renee Rutledge
Cover and interior design: Bethany Robertson

Distributed by Publishers Group West

dedication

mom. ashlee. pops + gma betty.
grandmother. mike D. monte + family. drake.
james. bud. sally. dave b. jessie. roxanna. ellen. john.
zack. arielle. max. KDH. rachael. drew. adam. cole. lizz.
santos. jordan. molly. connie. michelle von ebers. sarah.
mia. lauren. conor. dana. milcah. ulrika. gary. julie. atif.
leah. jeremy. caitlyn. emelina. austin. gil. yaz. lauren cecchi.
britt. stephanie. bethany. yelena. michelle. jacintha. alaina.
sam. garrett. jen. francine. merry. mona. crystal wagner.
fel. des. amalya. dina. alex. merideth. the price family.
briena. sara marie. koichi. beauvais. brakke. saunders. dakotah.
kym. joe. allie wolf. ernest. john. helena. jen lusker.
buttons. omer. osman. melissa. sabrina. tim. karen.
hunter. travis. evan. julien. anthony. keith. barb.
jen vinal. jack. melody. ryan. shannon. an.
nectar. rob. ricardo (@ itsaliving). brittany.
peter. matthew. rothstadt. zmanning.
hashhushash. collective craft.
john almanza. alex c.
jessica davis. jaclyn.
cassandra.
oasis.

to my FAMILY, FRIENDS, MENTORS, STUDENTS, and
BROOKLYN BARISTAS.

to my amazing CLIENTS.

and most importantly, ULYSSES PRESS.
especially ALICE.

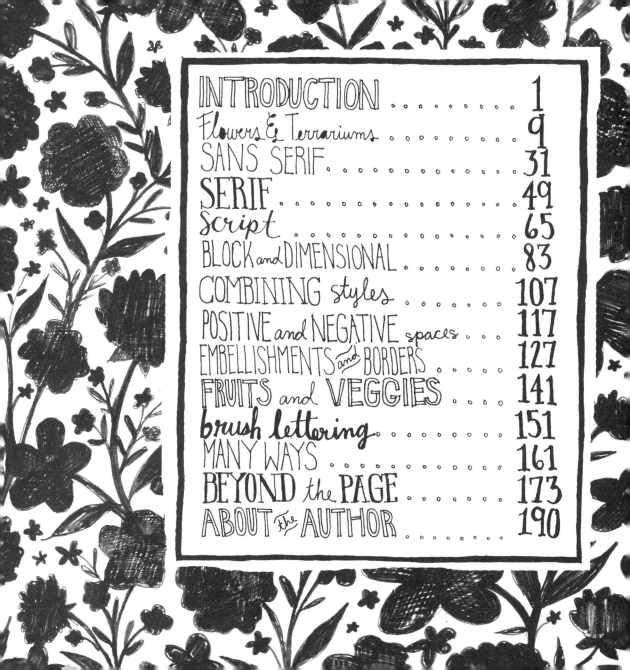

#BotanicalLetterBook

SHARE your hand-lettering creations with the world!

introduction

i started HAND LETTERING just like anybody else did—DOODLING in the margins of my middle-school notebooks. i would write my name OVER & OVER in BLOCK, BUBBLE, and cursive letters. i moved onto other styles until i had a LIBRARY of letters.

now, 15 years later, i bring a NOTEBOOK with me wherever i go. i find INSPIRATION everywhere—from an old sign to GRAFFITI on a wall to FLOWERS in cracks of pavement.

i hope this book inspires the BOTANICAL LETTERER in you! it is designed to offer you a boost into the art of lettering through simple STEP-BY-STEP instructions. most of what i have learned is through IMITATION and repetition. PRACTICE, PRACTICE, PRACTICE! find something you like and keep drawing it until it becomes your own. REMEMBER, there are no mistakes in hand lettering—find BEAUTY in the IMPERFECTIONS. Use the prompts in this book to help your art FLOURISH and HAVE FUN!

— Bethany

1

tools

these are all my personal faves, but you should definitely try all kinds of tools to find what works for you.

pens

- PIGMA MICRON by Sakura of America
- COPIC MARKERS
- GELLY ROLL in white for dark paper
- PILOT PRECISE V5 extra fine tip
- PENTEL WATER BRUSH for brush lettering

paper

- TRACING PAPER
- GRAPH PAPER
- PLAIN WHITE PAPER

other stuff

- PENCIL
- ERASER
- PENCIL SHARPENER
- RULER or STRAIGHT EDGE

ANATOMY of a LETTER

THE STRUCTURE OF A CHARACTER

G ← spur

S — Beak, spine

U ↓ downstroke

ℬ ← lead-in-loop

stem → A ← serif

F ↑ foot

t ← cross stroke

b ← script

The ← ligature

P ← drop shadow

N ↑ stroke

D ↑ dropline

C ← sans serif

P ↓ upstroke → h

i ← tittle

 ← eye

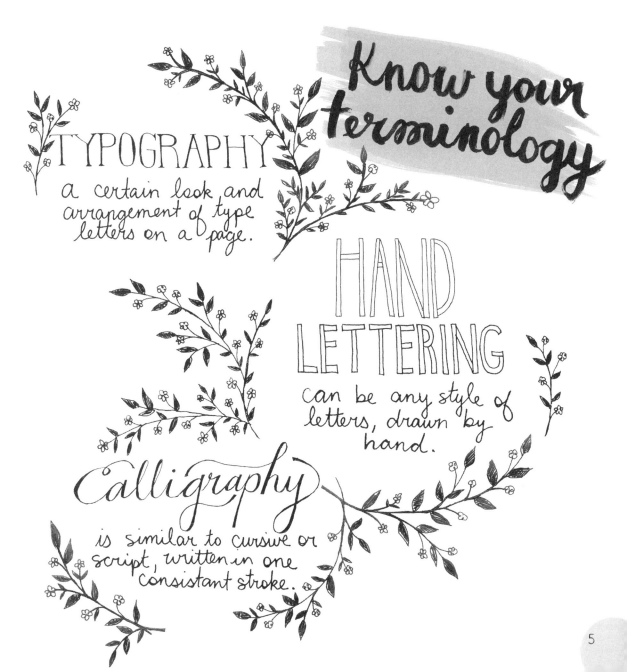

Know your terminology

TYPOGRAPHY
a certain look and arrangement of type letters on a page.

HAND LETTERING
can be any style of letters, drawn by hand.

Calligraphy
is similar to cursive or script, written in one consistant stroke.

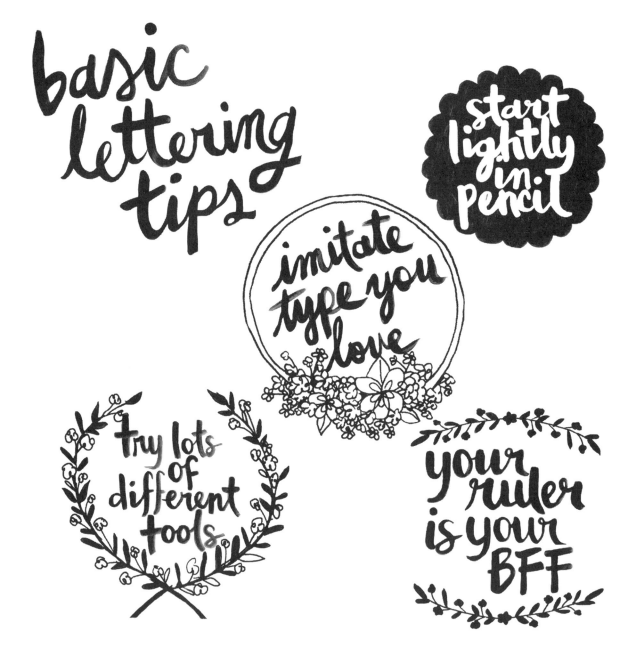

basic lettering tips

start lightly in pencil

imitate type you love

try lots of different tools

your ruler is your BFF

inspiration comes from everywhere

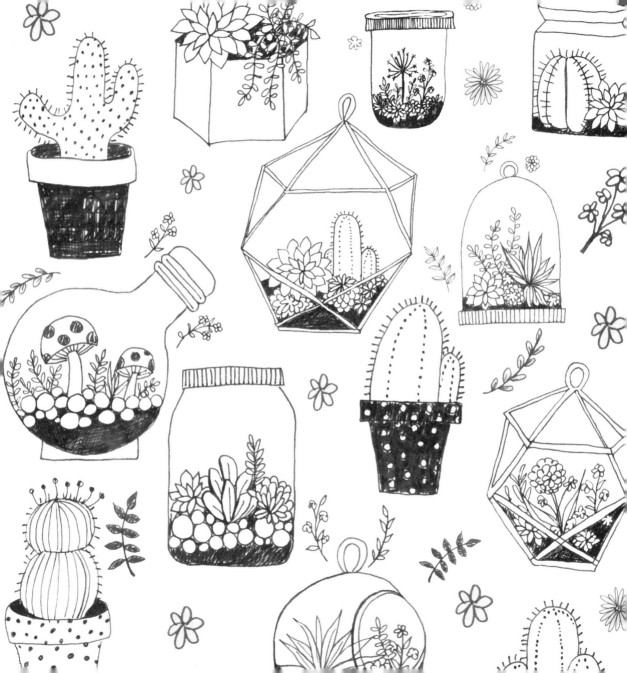

1

FLOWERS
& terrariums

flowers

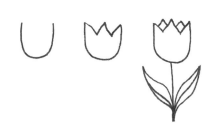

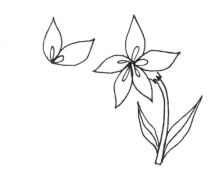

flowers

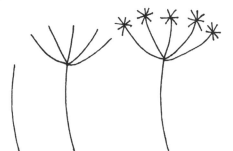

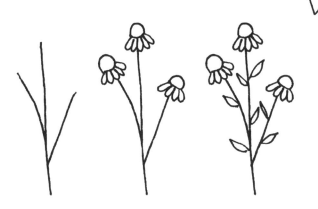

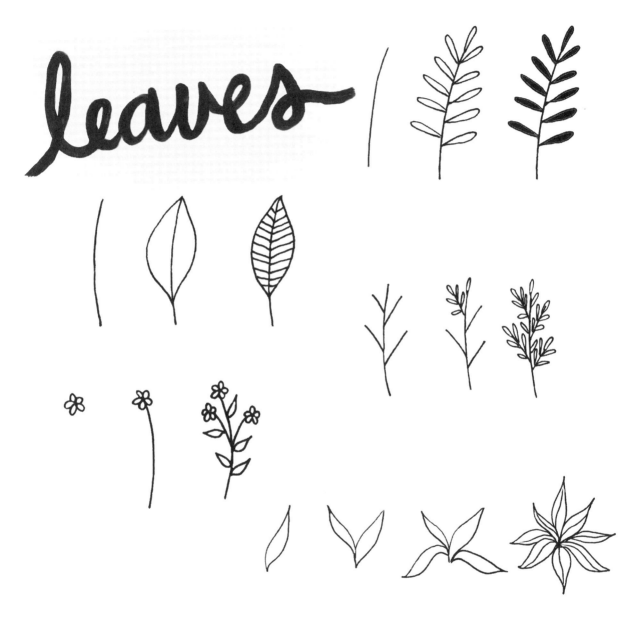

leaves

don't "leave" yet! it's your turn.

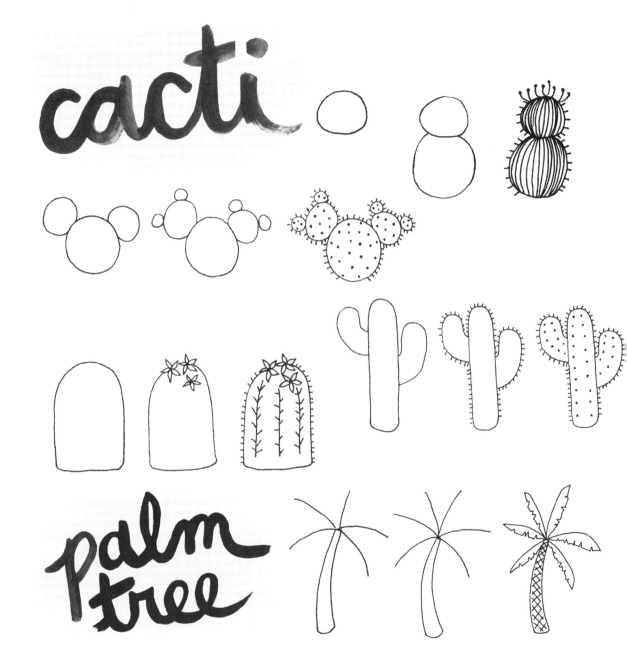

Make some
prickly
cacti

petal practice

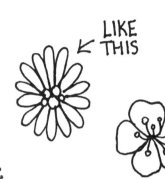

LIKE THIS

Creating clusters

tips:
- every flower should be touching another flower
- point the outside flowers and leaves outward.

① START WITH A FEW Large flowers.

② FILL IN WITH Small flowers.

③ ADD SOME Leaves AROUND THE EDGES.

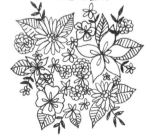

④ FILL IN THE BACKGROUND.

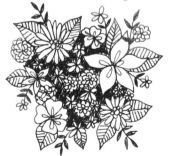

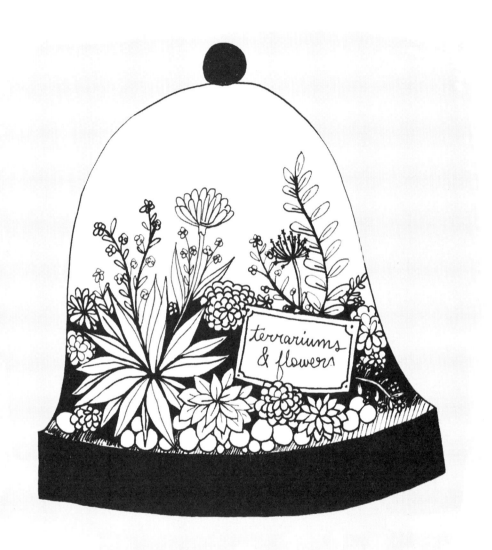

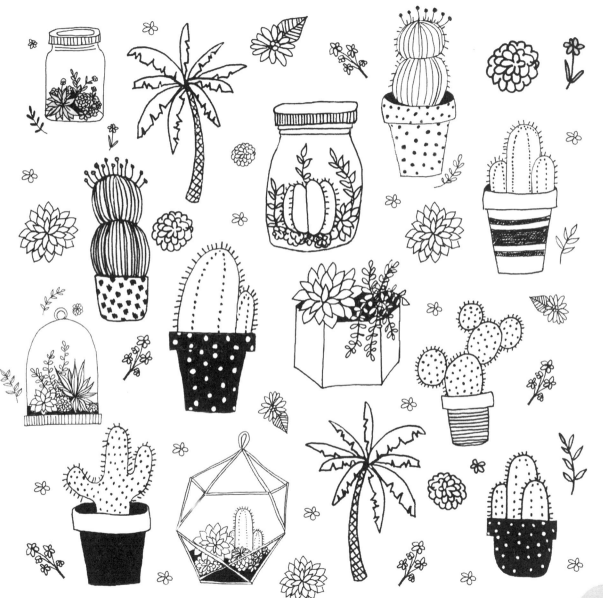

terrariums

fill the terrariums with FLOWERS & SUCCULENTS

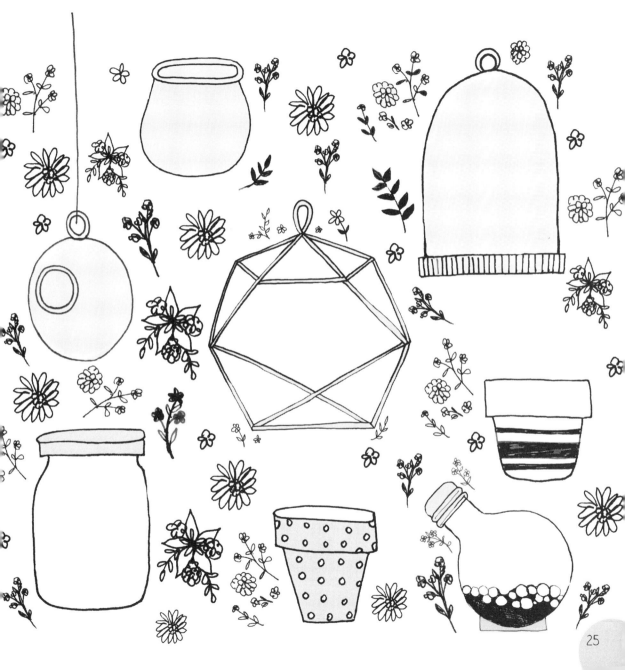

terrariums

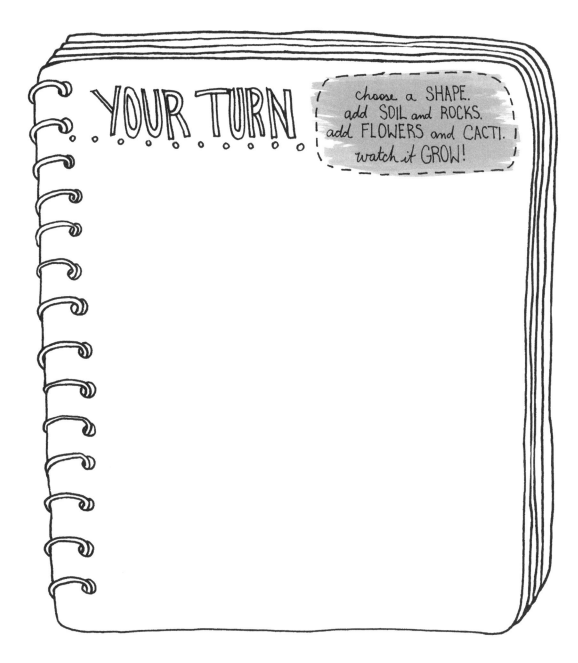

YOUR TURN

choose a SHAPE.
add SOIL and ROCKS.
add FLOWERS and CACTI.
watch it GROW!

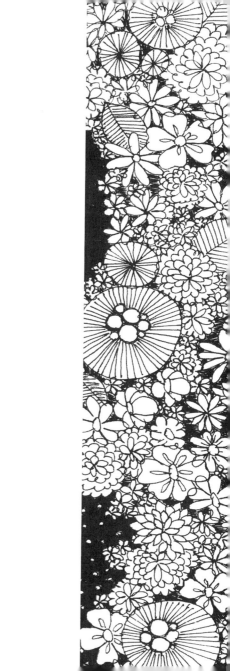

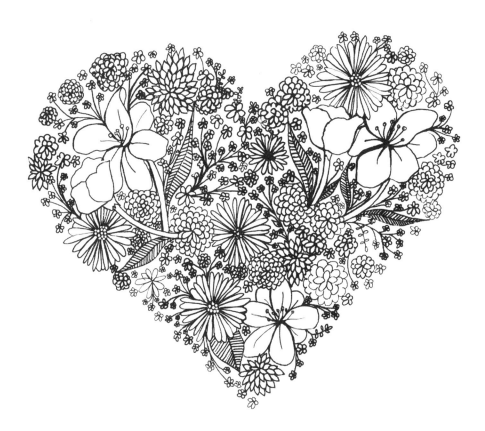

③

SANS SERIF

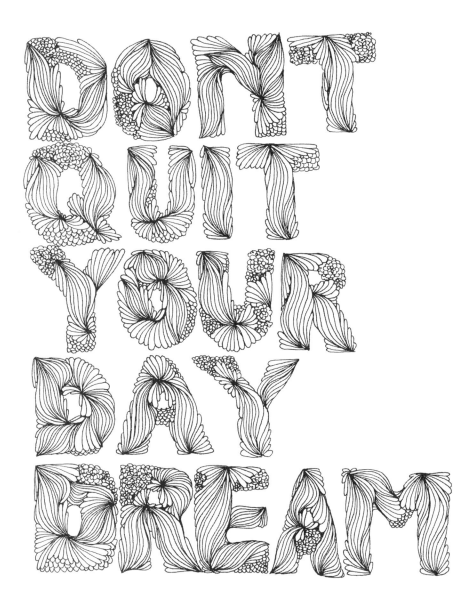

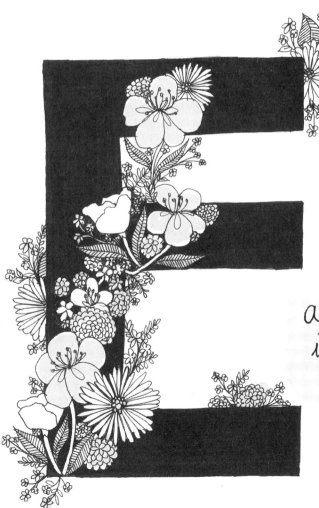

a SANS SERIF letter
is one without any
small projecting lines
at the ends.

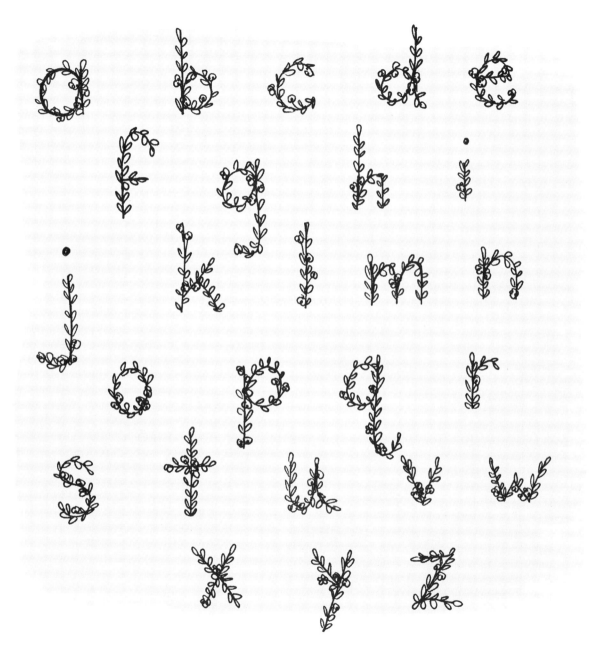

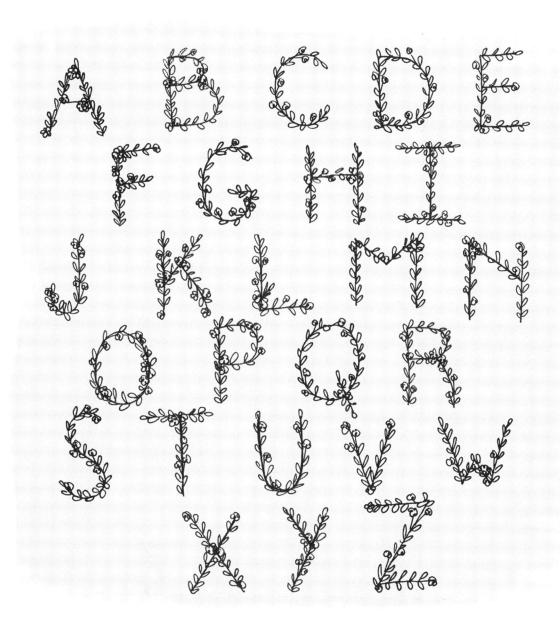

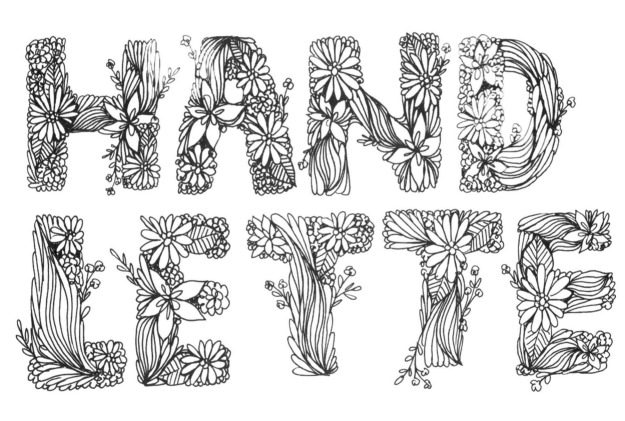

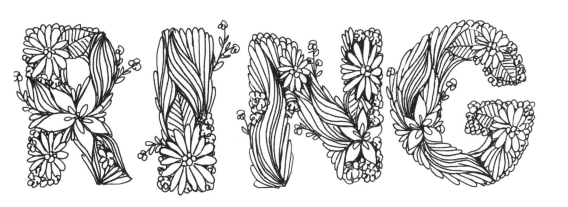

practice your SANS SERIF lettering
using the guides.
pay attention to differences in
UPPERCASE & lowercase.

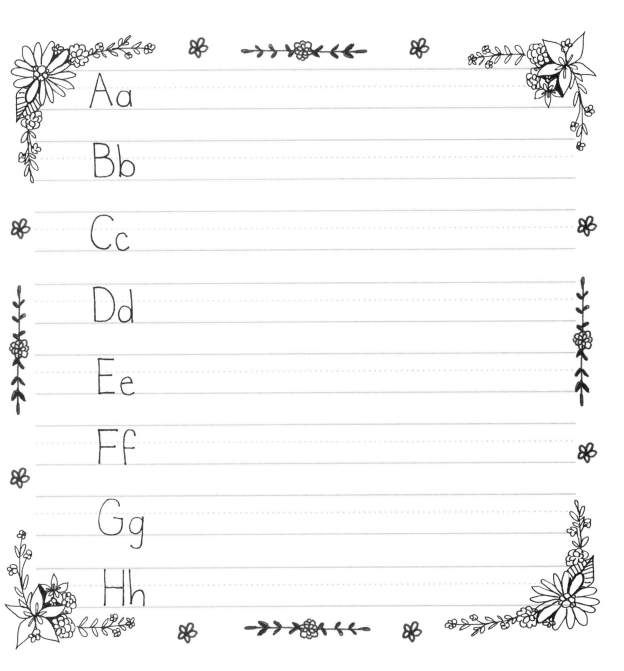

Aa

Bb

Cc

Dd

Ee

Ff

Gg

Hh

Ii

Jj

Kk

Ll

Mm

Nn

Oo

Pp

Qq

Rr

Ss

Tt

Uu

Vv

Ww

Xx

Yy

Zz

grow your own way

make these alphabets BLOOM!
start with small FLOWERS and
add LEAVES.

a b c d e

f g h i

j k l m n

o p q r

s t u v w

x y z

A B C D E
F G H I
J K L M N
O P Q R
S T U V W
X Y Z

PRACTICE YOUR UPPERCASE

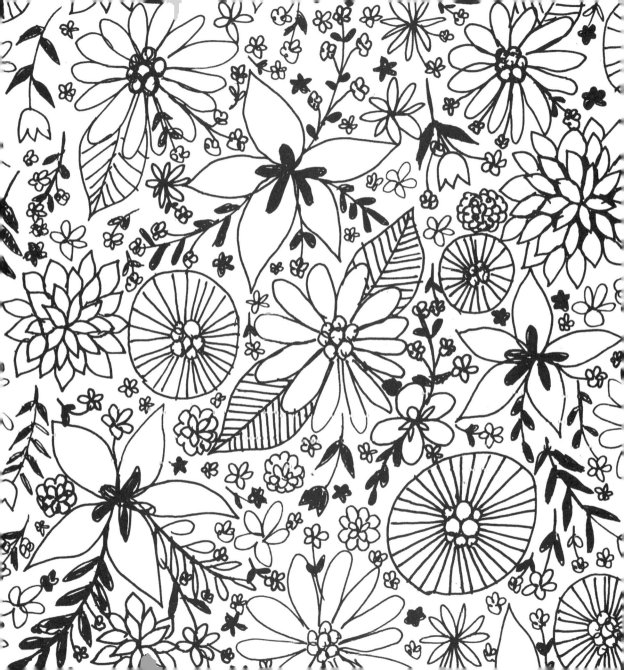

3

SERIF

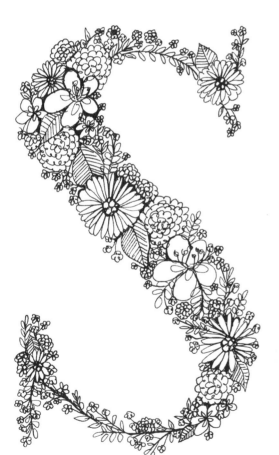

a **SERIF** is a small line or embellishment at the ends of a letter.

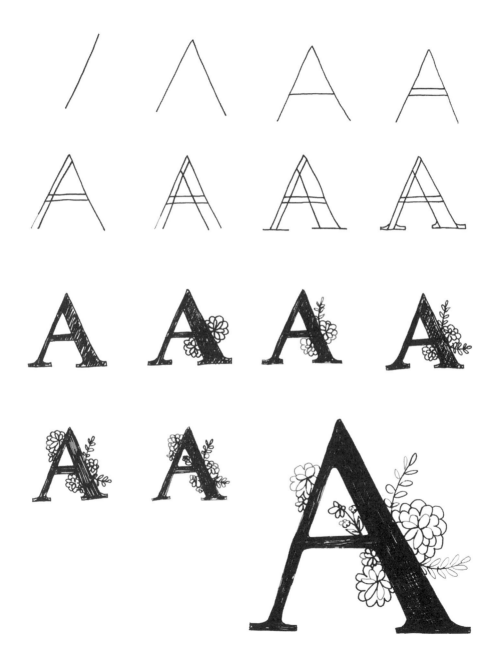

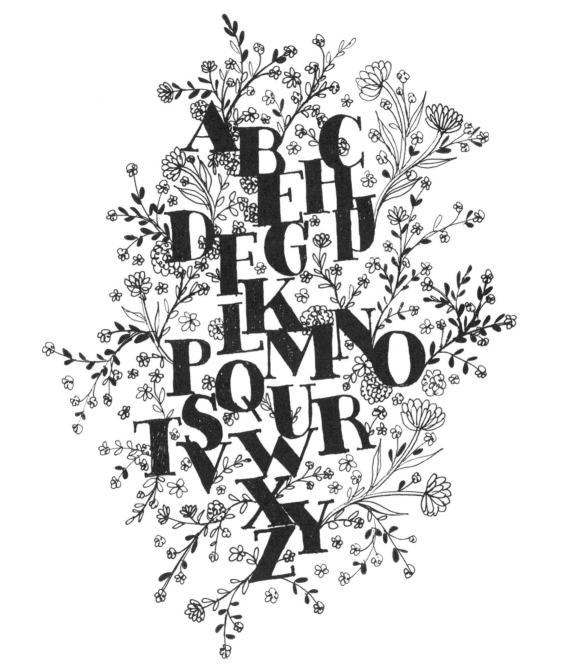

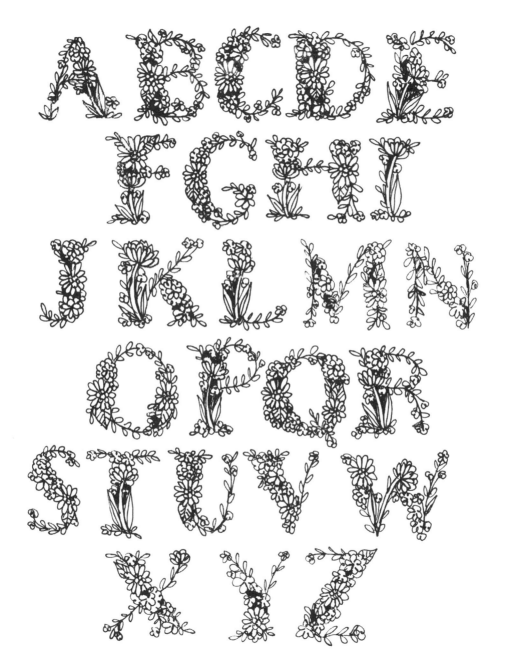

practice your SERIF, lettering
using the guides.
pay attention to differences in
UPPERCASE & lowercase.

Aa

Bb

Cc

Dd

Ee

Ff

Gg

Hh

Ii

Jj

Kk

Ll

Mm

Nn

Oo

Pp

Qq

Rr

Ss

Tt

Uu

Vv

Ww

Xx

Yy

Zz

fill it in with flowers

start with LARGE flowers.
add SMALL blooms and
LEAVES to fill the space

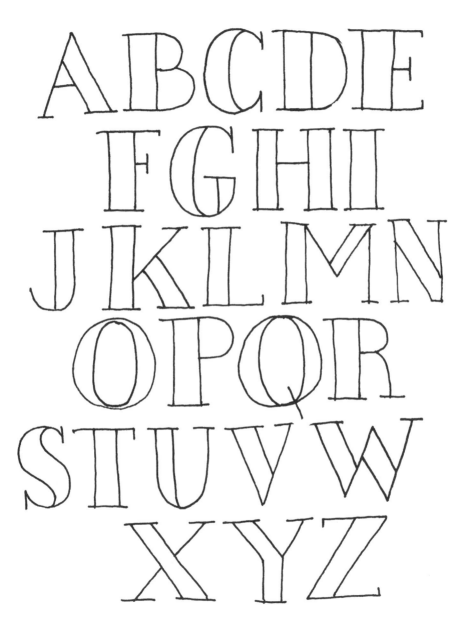

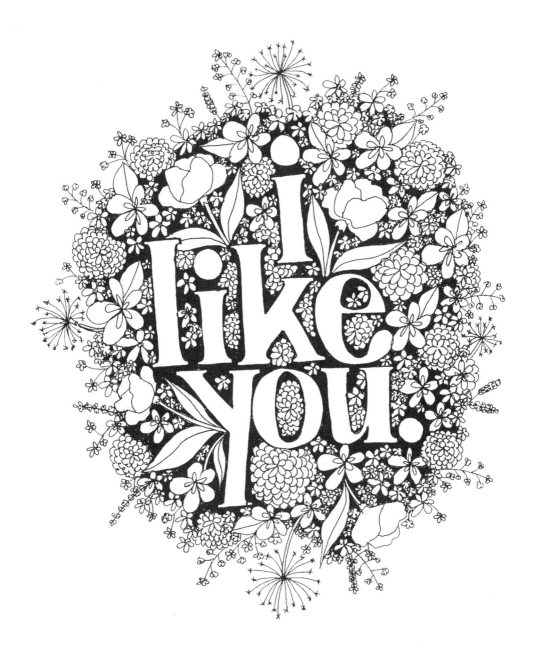

practice your lowercase

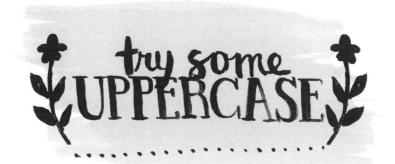

try some **UPPERCASE**

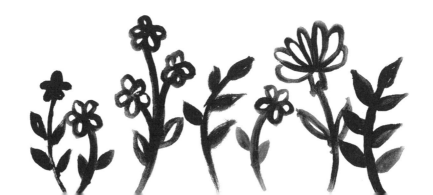

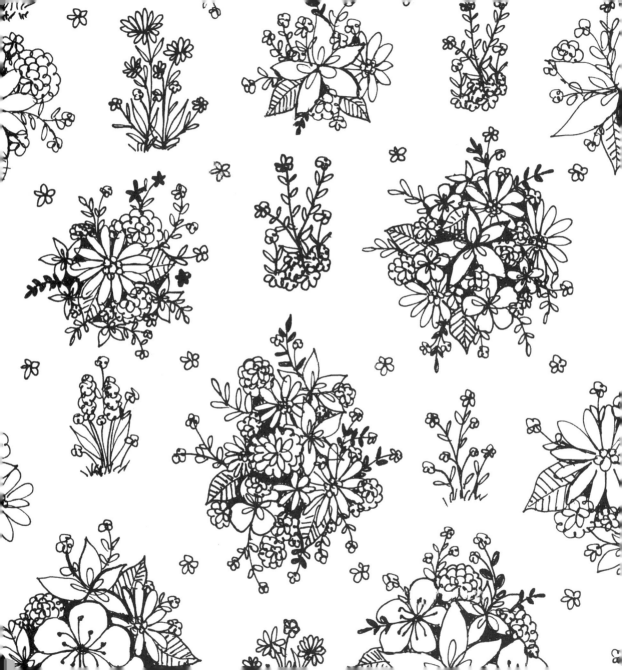

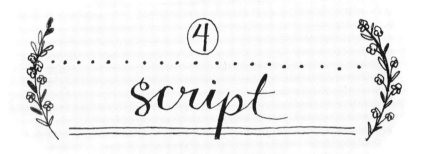

④ script

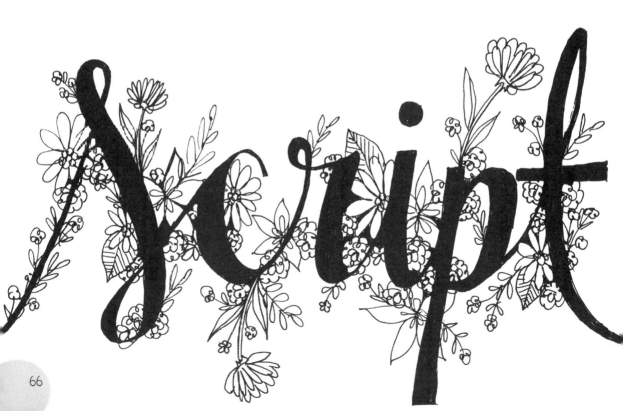

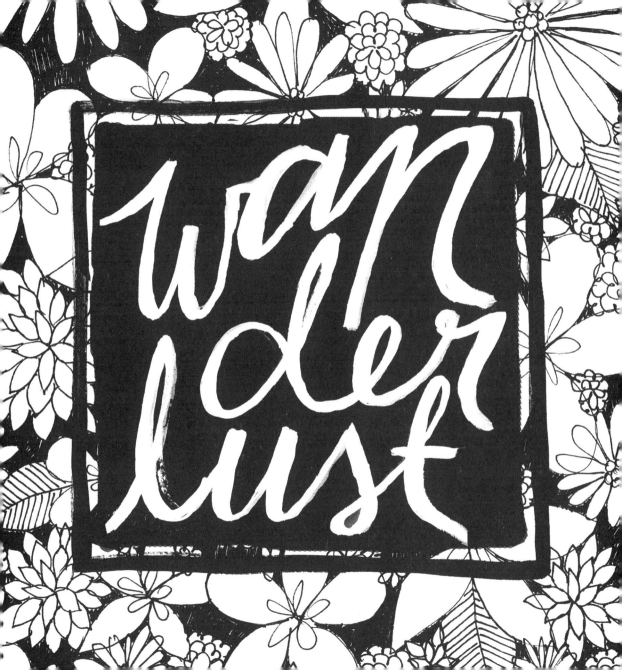

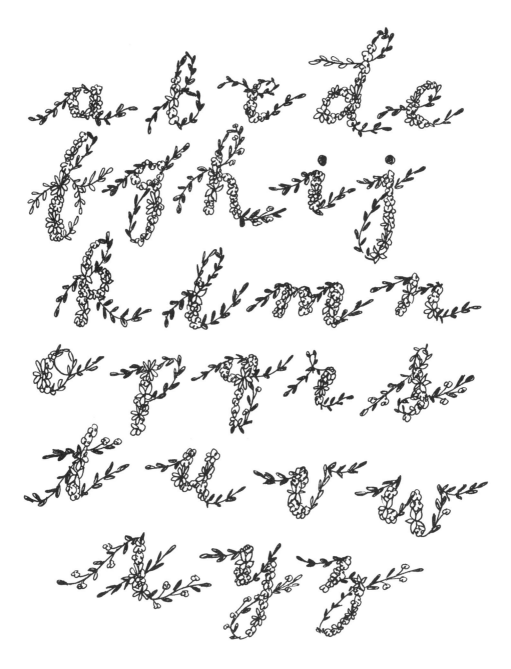

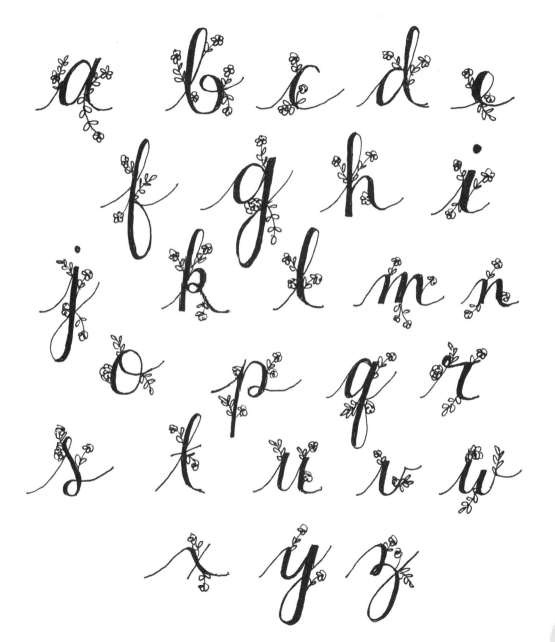

a b c d e

f g h i

j k l m n

o p q r

s t u v w

x y z

try some
lowercase

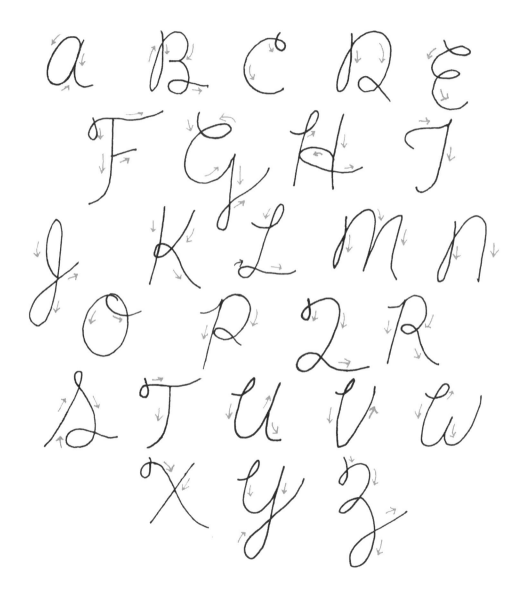

try some
UPPERCASE

practice your **script** lettering using the guides.

pay attention to differences in UPPERCASE & lowercase.

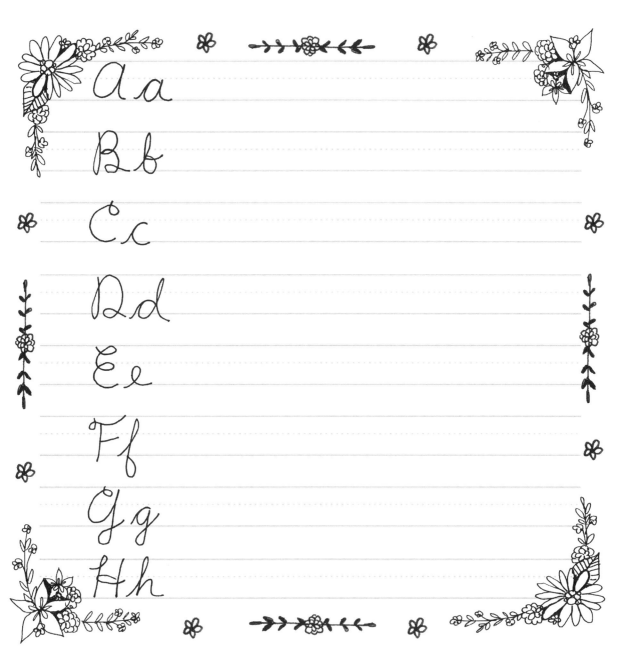

Aa

Bb

Cc

Dd

Ee

Ff

Gg

Hh

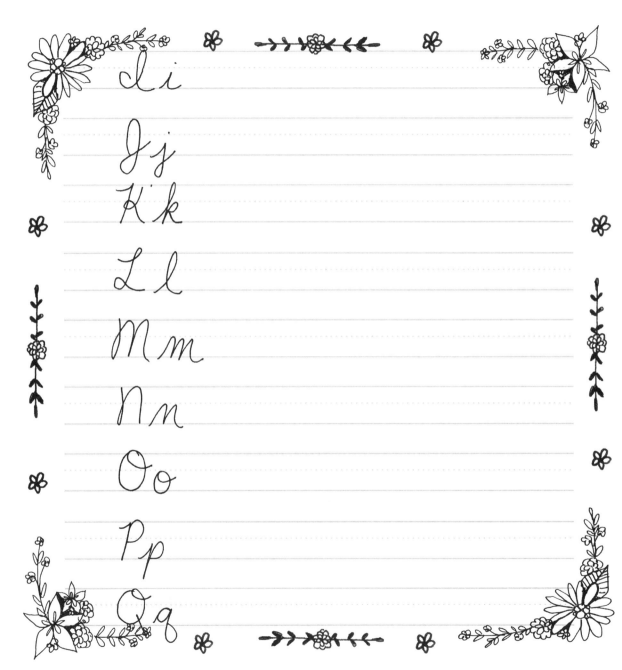

Ii

Jj

Kk

Ll

Mm

Nn

Oo

Pp

Qq

Rr

Ss

Tt

Uu

Vv

Ww

Xx

Yy

Zz

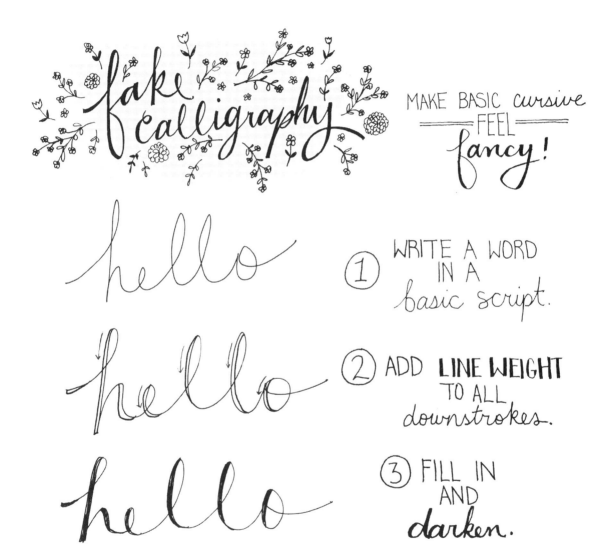

fake calligraphy

MAKE BASIC *cursive*
FEEL
fancy!

hello

hello

hello

1. WRITE A WORD IN A *basic script.*

2. ADD **LINE WEIGHT** TO ALL *downstrokes.*

3. FILL IN AND *darken.*

a b c d e
f g h i j
k l m n
o p q r s
t u v w
x y z

6

BLOCK & DIMENSIONAL

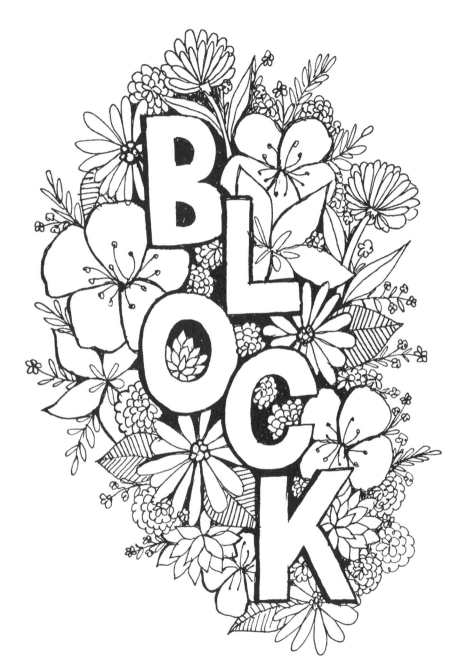

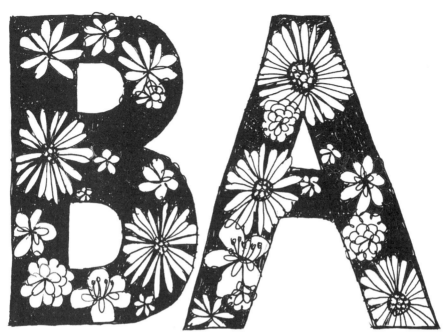
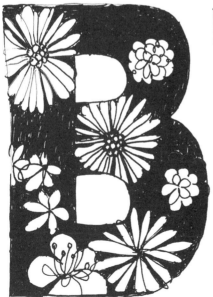
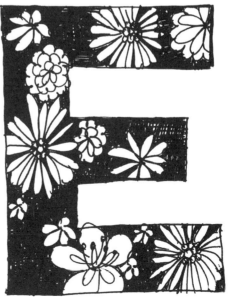

85

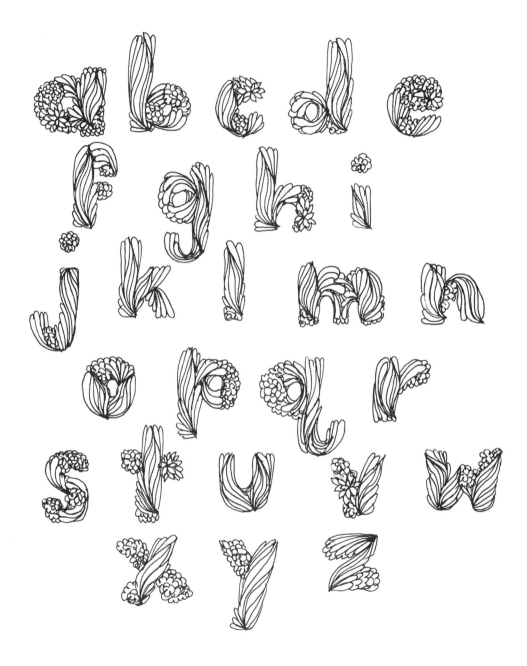

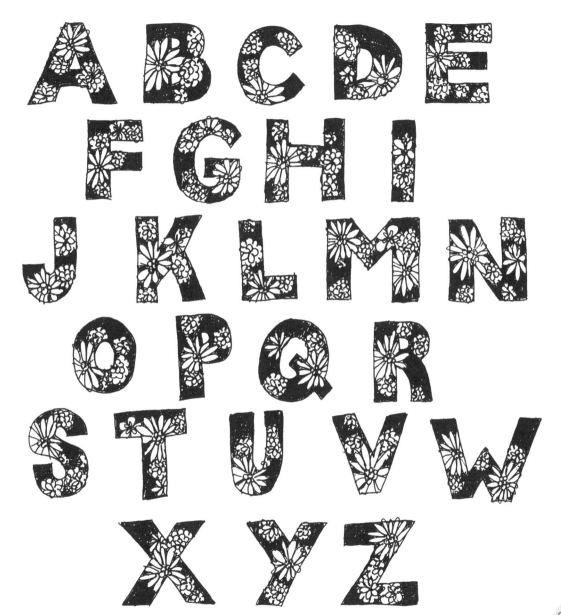

basic block lettering

①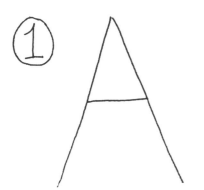

draw the FRAME

②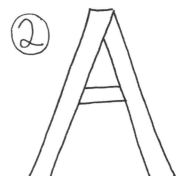

add WEIGHT

- Lightly draw one BLOCK letter in each large gridded box.
- Practice keeping the letters WIDE and UNIFORM.

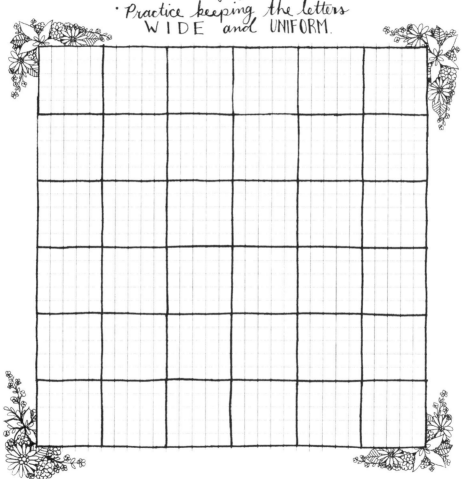

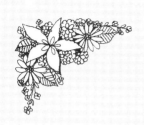
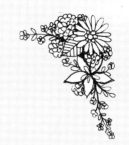
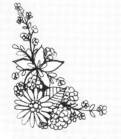
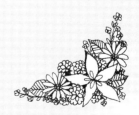

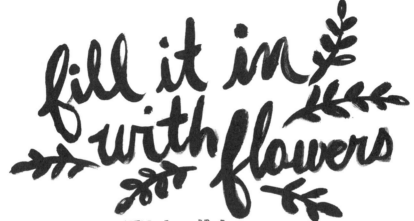

fill it in
with flowers

FILL IN the
BLOCK alphabet
with flowers

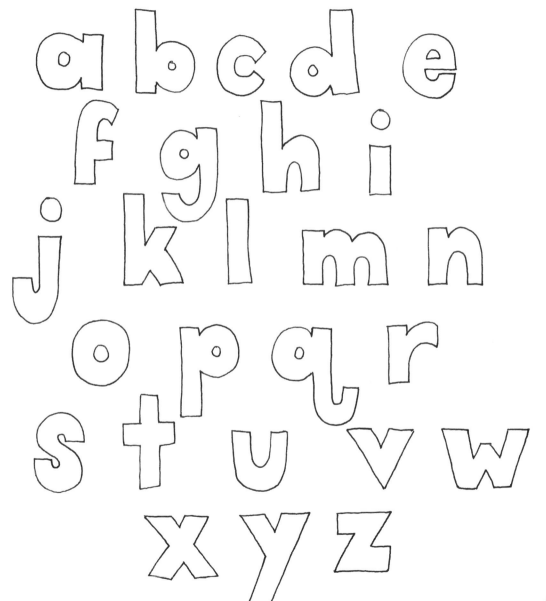

A B C D E

F G H I J

K L M N

O P Q R

S T U V

W X Y Z

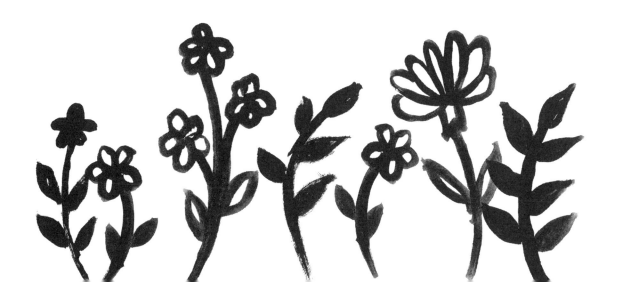

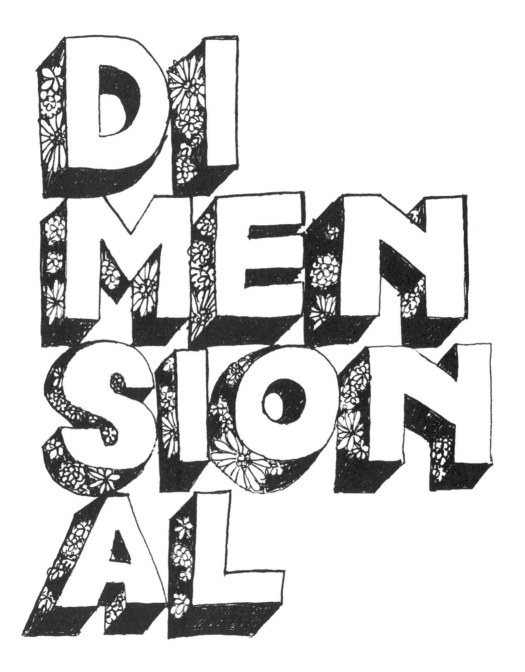

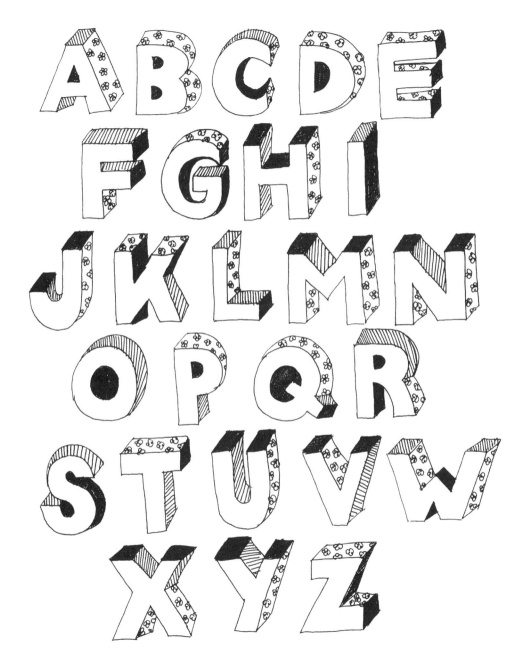

97

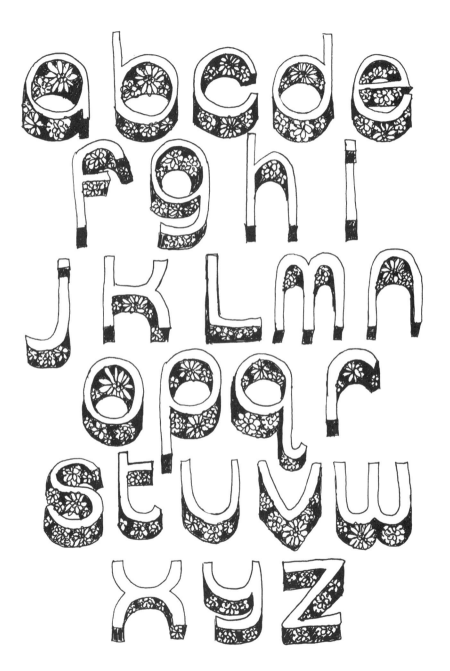

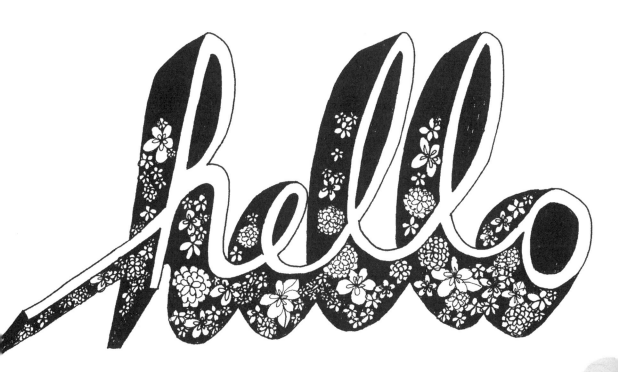

DIMENSIONS

DRAW a LETTER in BLOCK lettering.

MOVE the paper a tiny little bit in any direction and TRACE the letter again.

CONNECT the corners by drawing lines.

Place a second sheet of paper on top and TRACE the letter in pencil.

ERASE the overlapping lines.

FILL IN the 3-D.

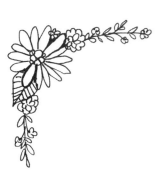
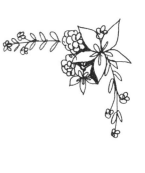

practice adding DIMENSIONS

block cursive

1. Using a PENCIL, draw your word in cursive.

2. Add width to the word, keeping the space between lines EVEN.

3. Erase extra lines in the intersecting lines.

Aa Bb Cc Dd Ee
Ff Gg Hh Ii
Jj Kk Ll Mm Nn
Oo Pp Qq Rr
Ss Tt Uu Vv Ww
Xx Yy Zz

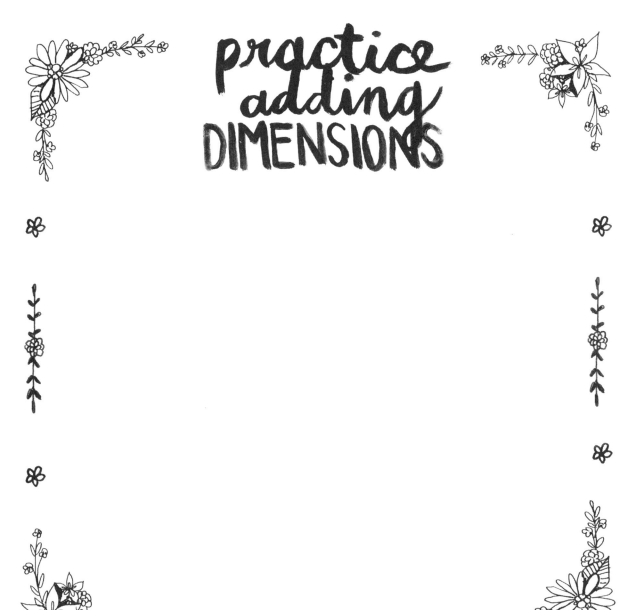

practice adding DIMENSIONS

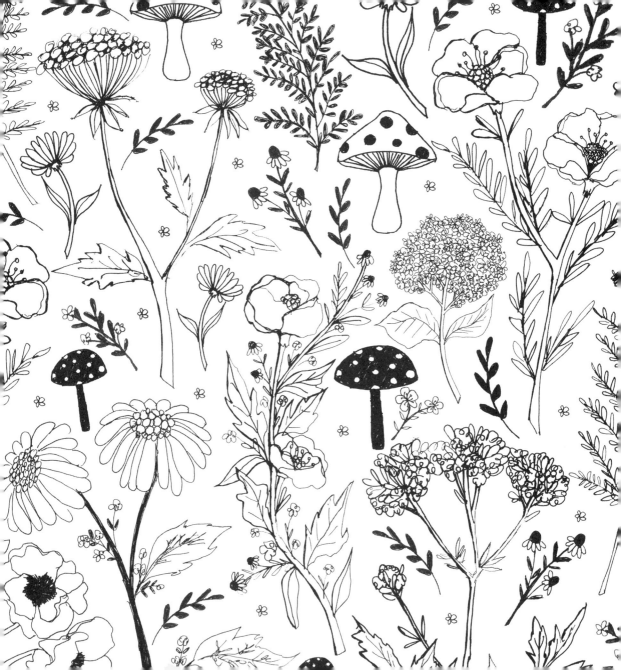

⑤

COMBINING *Styles*

combining styles

combine TWO styles
(THREE if you must)

- - - - - - - - - - - -

CONTRAST
is essential

- - - - - - - - - - - -

don't MIX moods

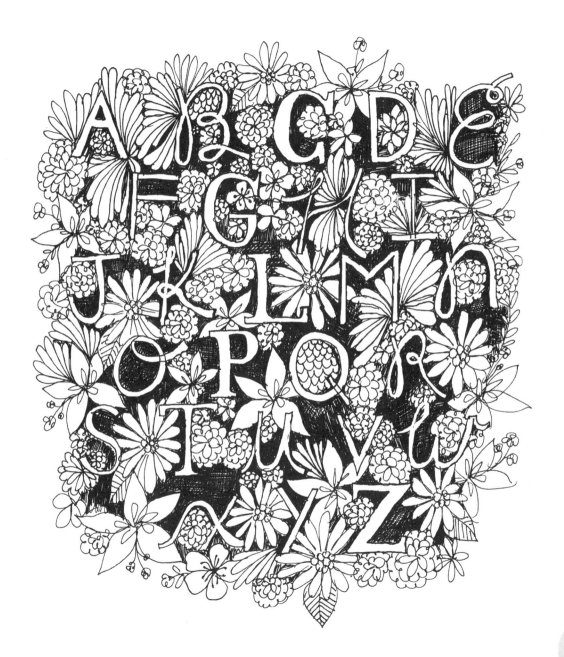

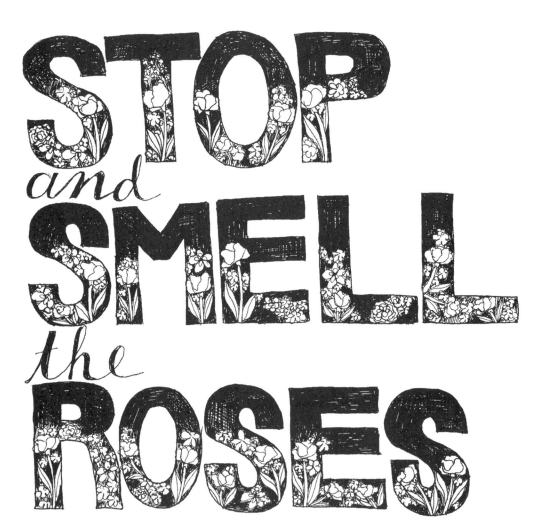

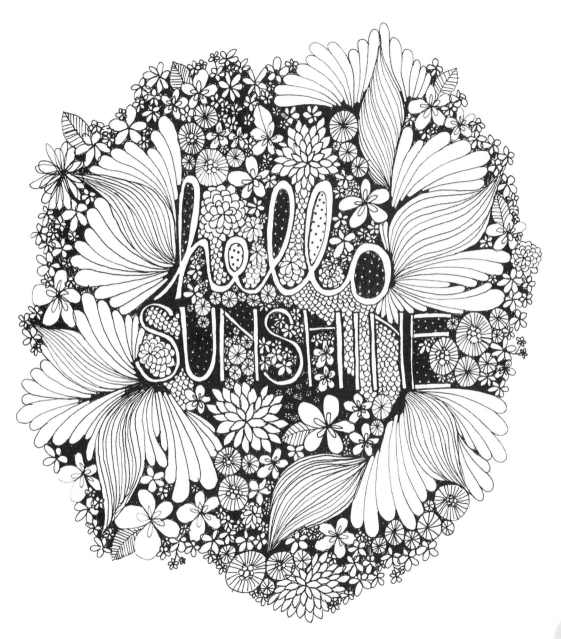

Use the boxes below to create
THUMBNAIL SKETCHES
of your final piece

HELLO
Beautiful

you
ARE
lovely

i need

VITAMIN

SEA

STAY
Wild
&
Free

OH
happy
day

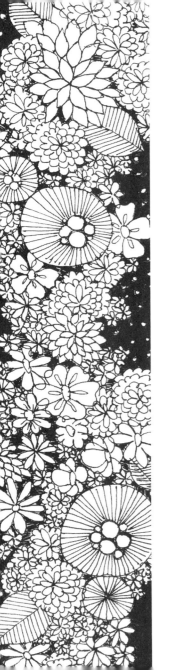

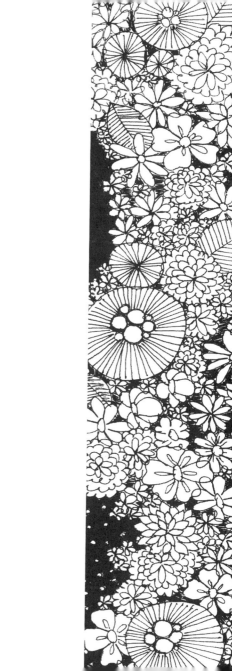

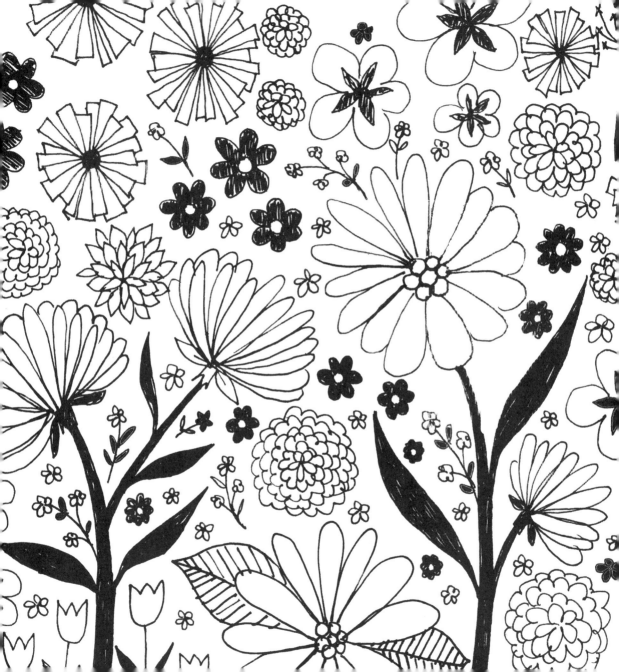

⑦ positive & negative SPACES

Positive & Negative space

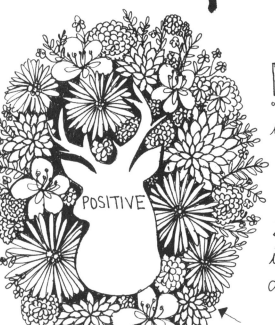

POSITIVE

NEGATIVE

POSITIVE SPACES
is the main shape or form.

NEGATIVE SPACES
is the empty space between and around the main shape or form.

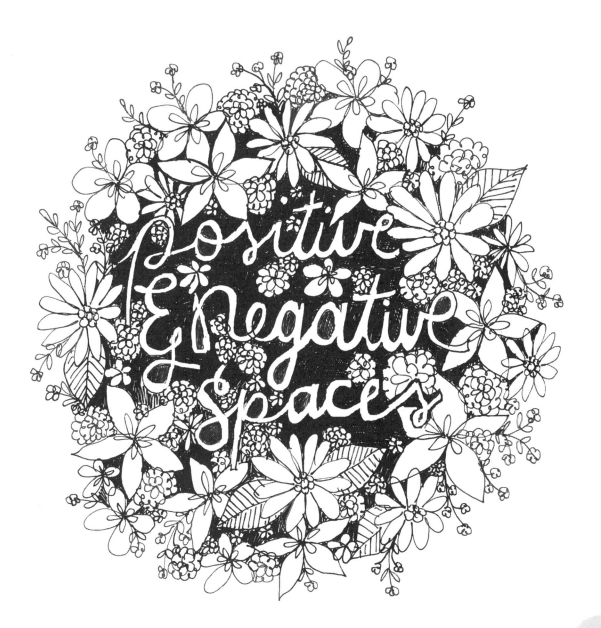

inside a SHAPE

i love you a latte

hello

SWEET ON YOU

what a cute pair

I heart YOU

DRAW a shape below.
add TEXT to fit inside.

inside a SHAPE

add flowers growing
AROUND the words.
○ ○ ○ ○ ○ ○ ○ ○ ○ ○ ○
start with LARGE blooms.
add SMALL blooms.
FILL IN with leaves.

hand
LETTERING

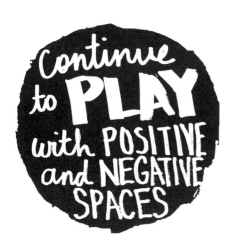

continue to **PLAY** with POSITIVE and NEGATIVE SPACES

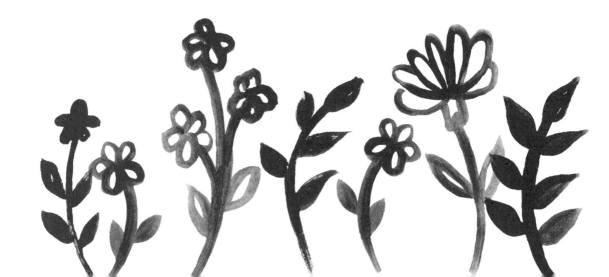

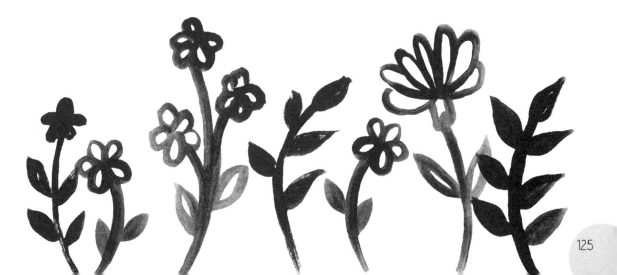

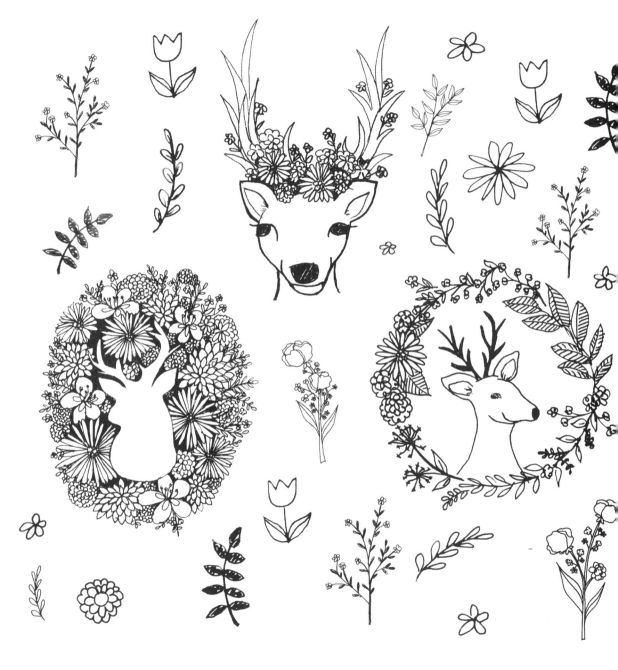

8

EMBELLISHMENTS *and* BORDERS

embellish-ments

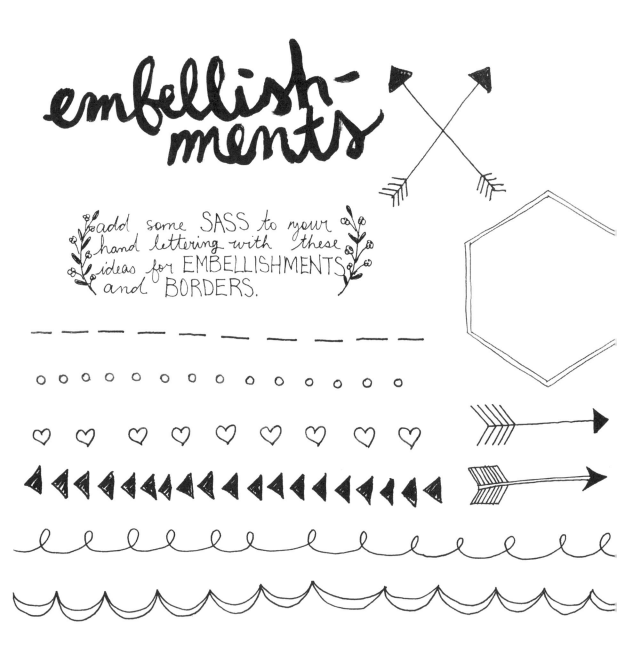

add some SASS to your hand lettering with these ideas for EMBELLISHMENTS and BORDERS.

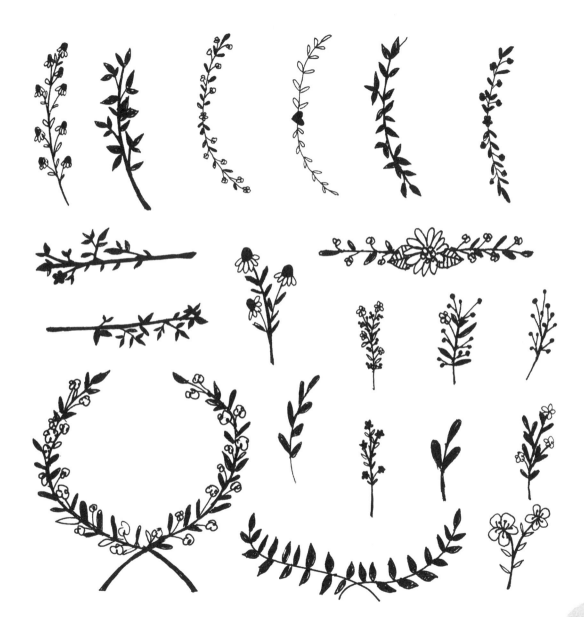

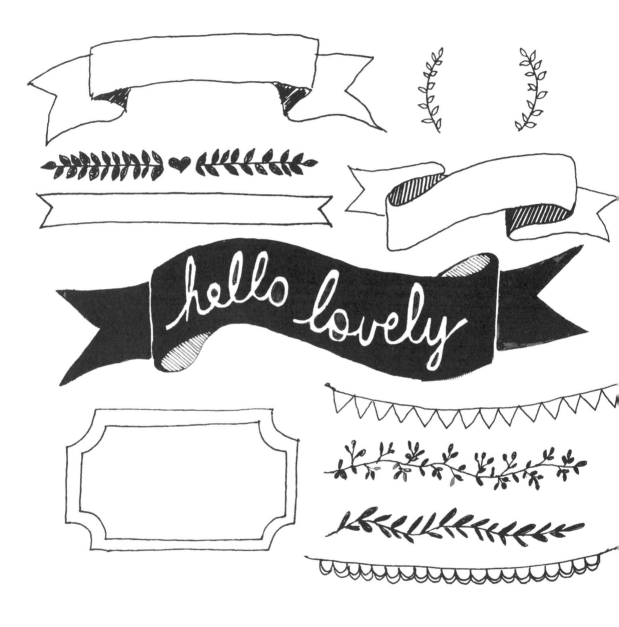

hello lovely

logos

loveless designs

LOVELESS DESIGNS

LOVELESS designs

LOVELESS DESIGNS
· ILLUSTRATION ·

loveless DESIGNS

sketch your
INITIALS
several times below.

add ACCENTS around
your logos, keeping the
text as the focus.

continue to develop your
logo until you feel it
REPRESENTS YOU!

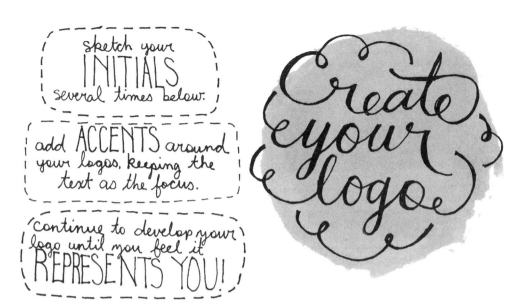

create your logo

139

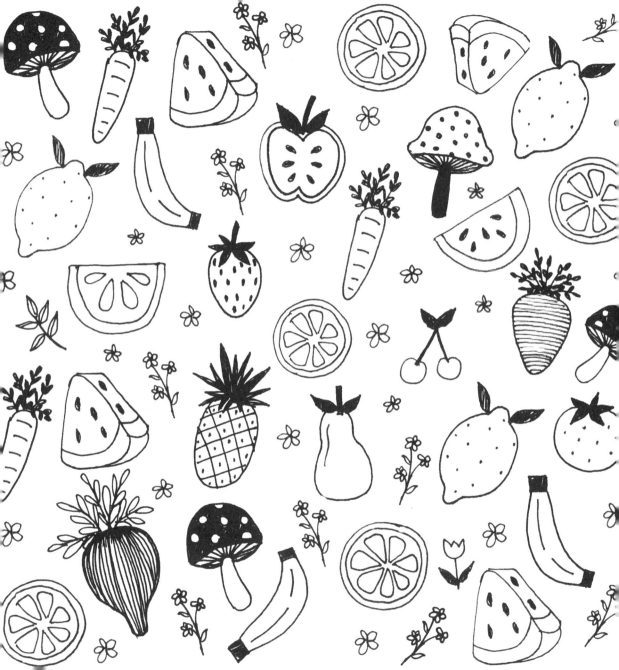

9

fruits & veggies

fruit

WATER melon

APPLE

PEAR

PINE apple

draw your fruit

Straw-BERRY

banana

GRAPEfruit

LEMON

orange

FOLLOW THE STEPS
to create
CUTE FRUIT.

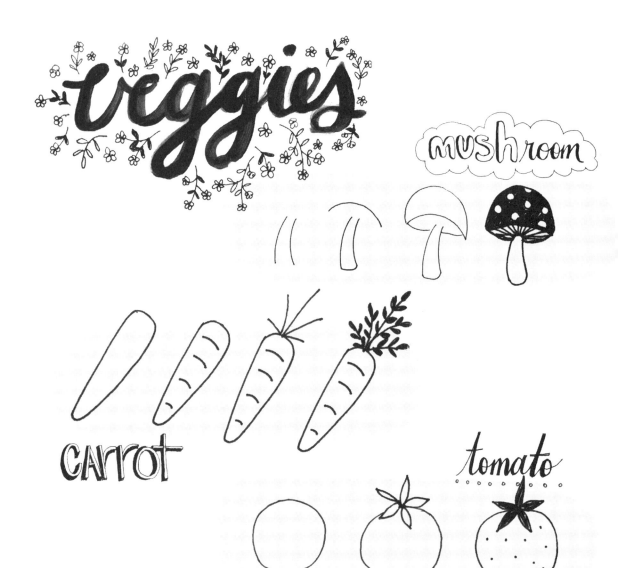

veggies

mushroom

carrot

tomato

make some veggies

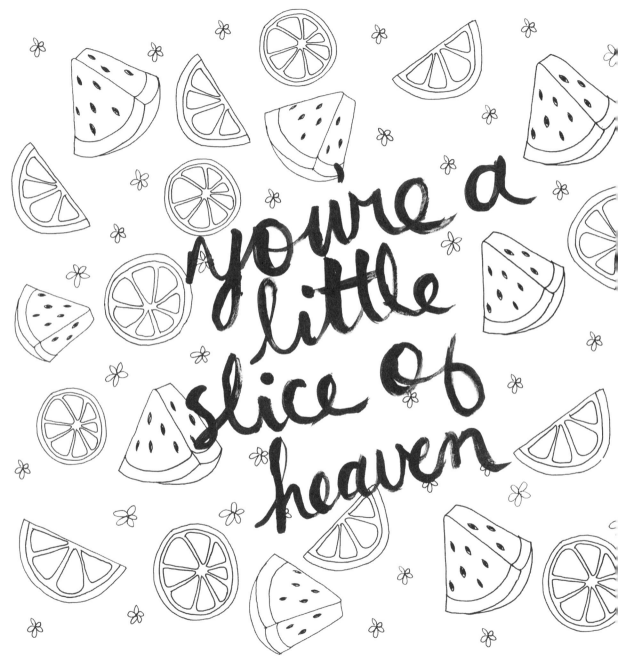

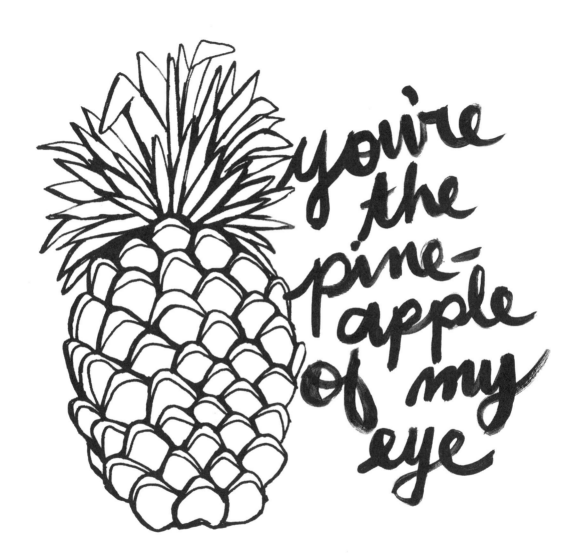

you're the pine-apple of my eye

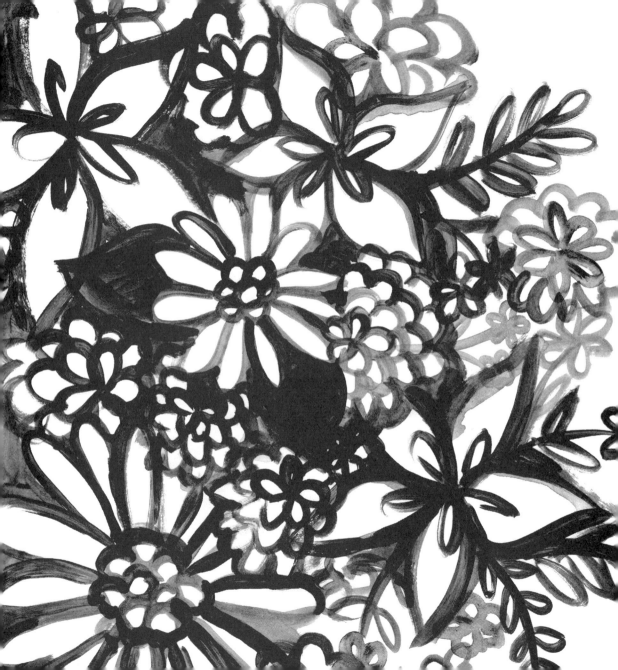

10

brush lettering

BRUSH LETTERING

brush lettering

LETTERING BRUSH

brush lettering

BRUSH LETTERING

lettering brush

BRUSH LETTERING

brush lettering

LETTERING BRUSH

LETTERING BRUSH

brush lettering

BRUSH LETTERING

LETTERING

tools

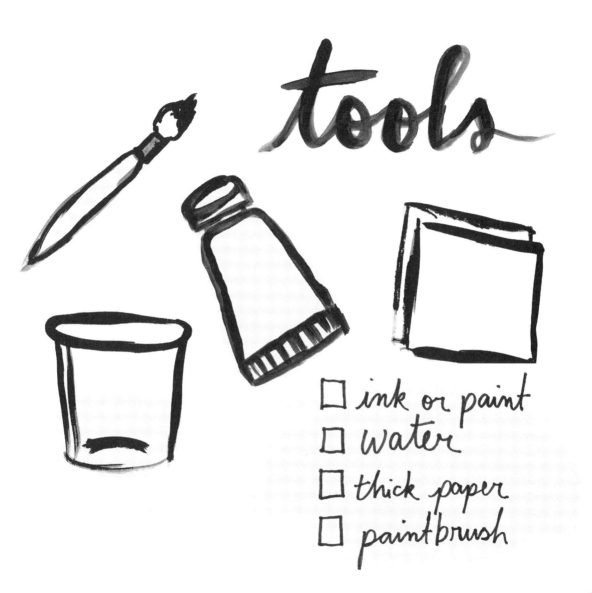

- ☐ ink or paint
- ☐ water
- ☐ thick paper
- ☐ paintbrush

153

abcde
fghijkl
mnopqr
stuvw
xyz

A B C D E
F G H I
J K L M N
O P Q R
S T U V W
X Y Z

tips

less water = rougher edges

change pressure for line variation

more water = smoother results

play around with transparency

11

MANY WAYS

1 Letter 100 ways

Choose a LETTER to DRAW 100 ways!

try a variation
of STYLES,
LINE WEIGHT,
& accents.

Now, think of a WORD that begins with the LETTER from the previous pages.

DRAW the WORD according to the prompts following and add your own STYLE.

lowercase

SANS
SERIF

UPPERCASE

SERIF

LEFT-
HANDED

RIGHT-
handed

LINE WEIGHT

TALL

script

WIDE

S L O W

FAST

DIMENSIONAL

BLOCK

slant

ARCH

add a BORDER

inside a SHAPE

add ACCENTS

texture/pattern

12

BEYOND the PAGE

beyond the page

hello

THIS SECTION SHOWS *ideas* FOR USING YOUR *botanical lettering* SKILLS FOR OTHER *fun projects.*

flower crown

1. DRAW a CLUSTER of flowers onto cardstock in a line similar to the one shown.

2. CUT around the flowers and PUNCH a small hole at each end.

3. TIE one 10-inch piece of yarn or ribbon through each hole.

4. Place flower crown on and TIE a BOW in back.

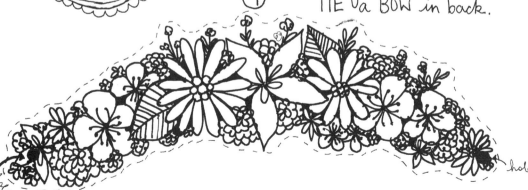

hole

hole

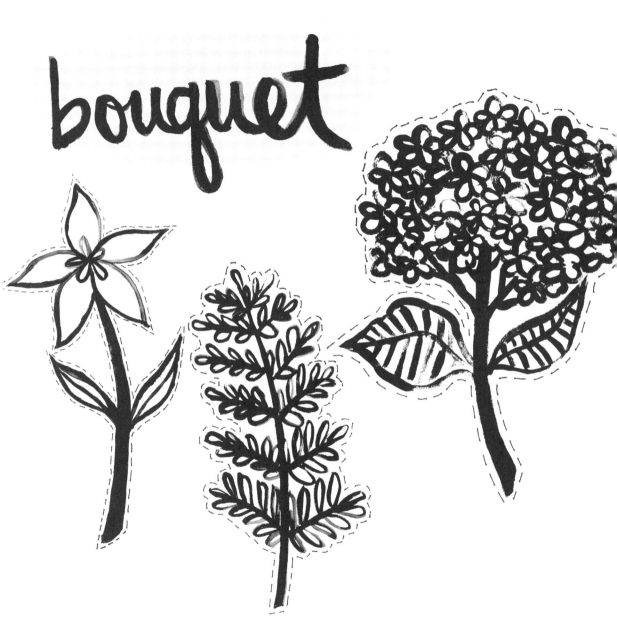

bouquet

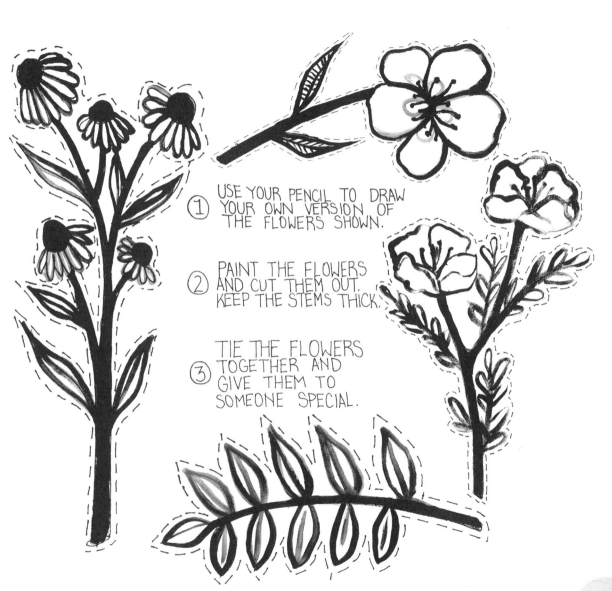

1. USE YOUR PENCIL TO DRAW YOUR OWN VERSION OF THE FLOWERS SHOWN.

2. PAINT THE FLOWERS AND CUT THEM OUT. KEEP THE STEMS THICK.

3. TIE THE FLOWERS TOGETHER AND GIVE THEM TO SOMEONE SPECIAL.

paper cacti

DRAW the template on heavy cardstock.

CUT around each cactus.

CUT a slit in the shaded areas.

SLIDE pieces together like the structures shown.

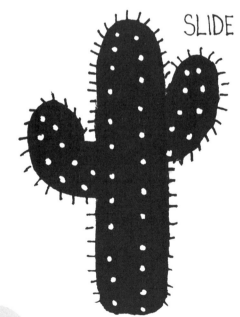

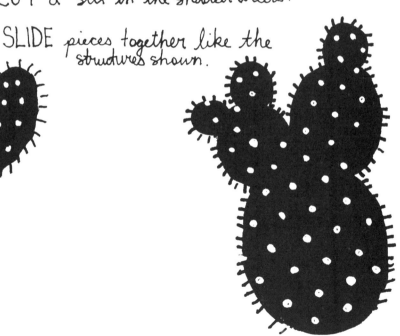

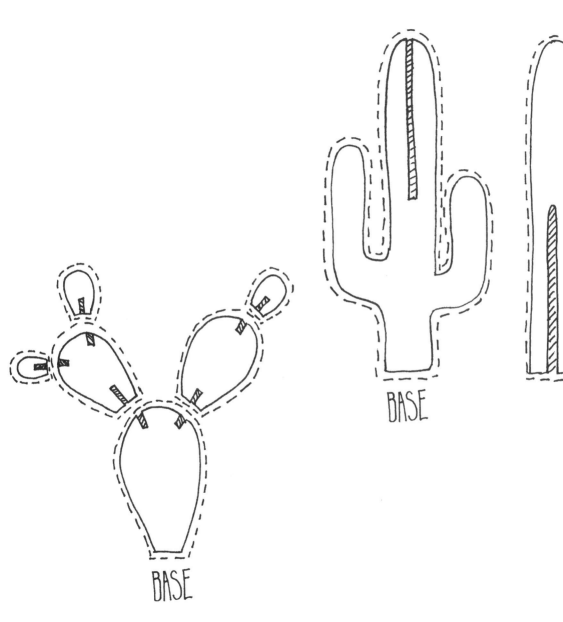

BASE

BASE

Mini Banners

hooray!

USE THE TEMPLATES AS A
GUIDE FOR CREATING
YOUR OWN BANNERS!

cut here

fold here

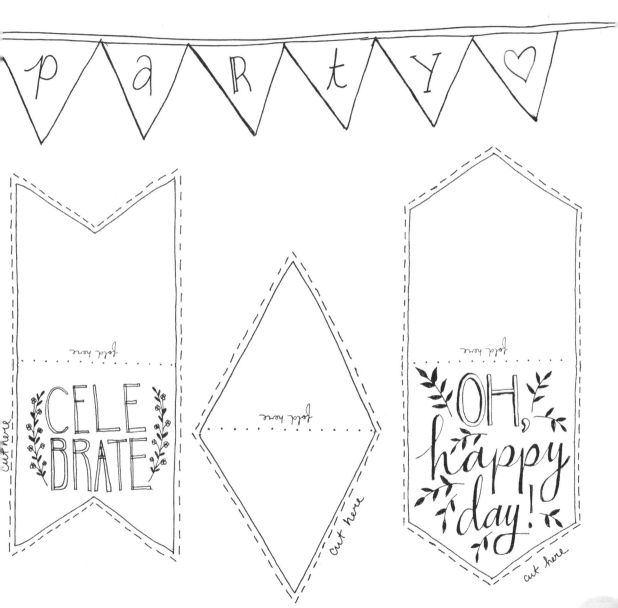

Mini Journal

Use 5 sheets of copier paper and 1 sheet of cardstock. Cut down to desired size.

1

THREAD 12 INCHES OF STRING THROUGH A NEEDLE AND DOUBLE KNOT THE END.

FOLD the cardstock and pages in half.

2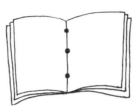

PUNCH three holes on the fold through all pages using a safety pin.

3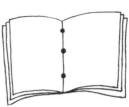

PULL the needle through through the <u>middle</u> hole from the inside, leaving a tail of string.

PULL the needle back to the inside through the <u>bottom</u> hole.

4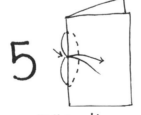

THREAD the needle out through the <u>top</u> hole.

5

PULL the needle in through the <u>middle</u> hole.

6

CUT the needle off and tie the two ends together.

heart envelope

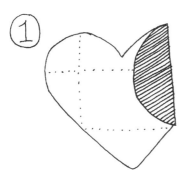

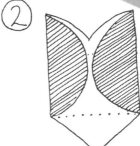

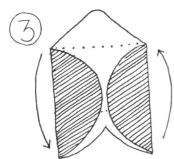

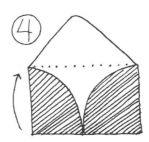

Weekly planner

① Use a RULER to draw seven (7) EQUAL rows or columns.

② Designate each row or column with a DAY OF THE WEEK.

③ Create a FLOWERY BORDER around the planning grid.

④ SCAN and SAVE your planner page.

⑤ PRINT a new planner page each week.

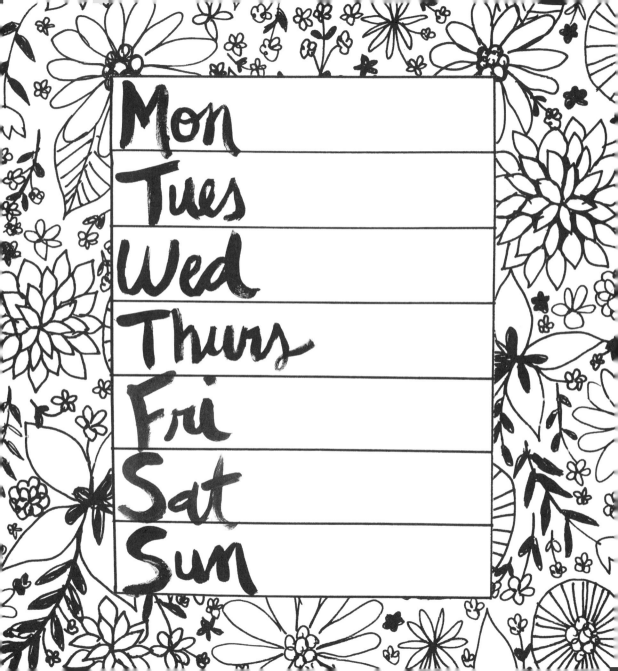

Mon	
Tues	
Wed	
Thurs	
Fri	
Sat	
Sun	

rsvp

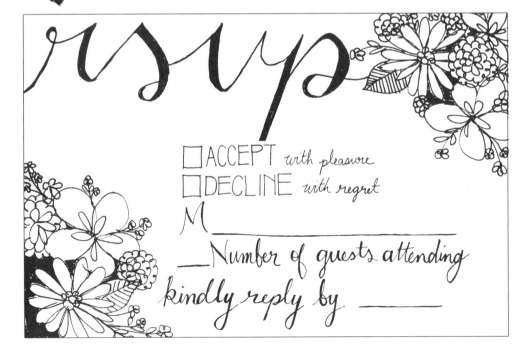

rsvp

☐ ACCEPT with pleasure
☐ DECLINE with regret

M _____

___ Number of guests attending

kindly reply by _____

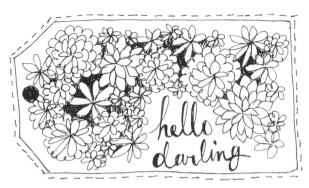

1. DRAW the tag on cardstock.
2. CUT out and punch a hole.
3. HAND LETTER with a a special message!

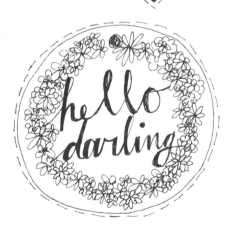

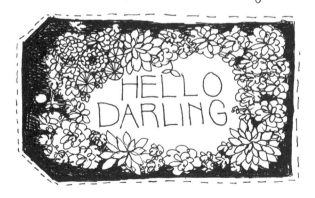

187

table #s

table

TIPS:

- Make table #s large enough to be seen from a distance.

- DRAW table #s on a hard material, such as WOOD.

- Make the table # colors match the centerpiece flowers!

- If using paper table #s, insert in small standing picture frames.

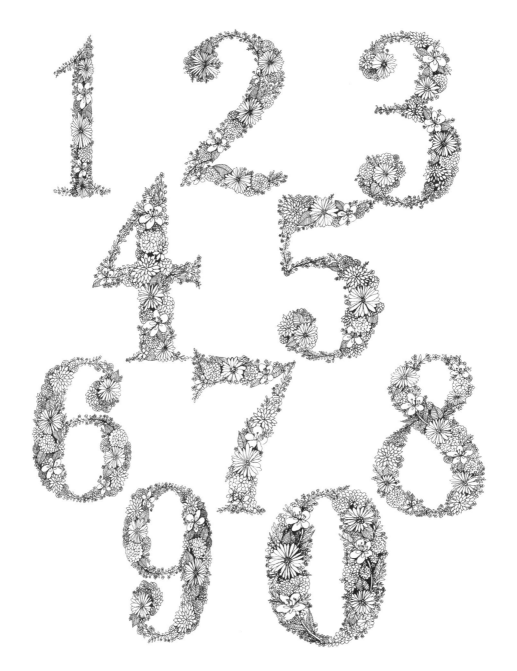

about THE author

bethany robertson

BETHANY ROBERTSON is an illustrator and designer based in BROOKLYN, NY.

She has an MFA in visual arts from RUTGERS UNIVERSITY and an MS in art education from THE UNIVERSITY of TENNESSEE, KNOXVILLE.

Bethany enjoys DRAWING, PIZZA, FLOWERS, ICE CREAM, and the BEACH.

WWW.BETHANYROBERTSON.COM

 @LOVELESS_DESIGNS

 bethany@bethanyrobertson.com